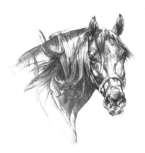

The Art of Drawing
HORSES & PONIES

From the earliest cave drawings to the modern masters, artists have long been inspired by the horse as a subject. Horses have an elegance and spirit that we're naturally attracted to and intrigued by. With their fluid lines, powerful muscles, and graceful motions, it's no wonder that these extra-ordinary creatures have frequently been celebrated by artists throughout the ages. And now you can learn to draw horses, too, even if you're never picked up a drawing pencil. In this book, you'll find the basics of horse anatomy and correct proportion, as well as special tips for drawing facial features, ears, hooves, and manes. You'll also learn how to render these beautiful and expressive animals in exciting action poses—racing, jumping, and galloping. Just follow the simple steps in this book, and soon you'll develop your own style for drawing these magnificent animals.

CONTENTS

Getting Started

Drawing is just like writing your name.

You use lines to make shapes. In the art of drawing, you carry it a bit further, using shading techniques to create the illusion of three-dimensional form. Only a few basic tools are needed in the art of drawing. The tools necessary to create the drawings in this book are all shown here.

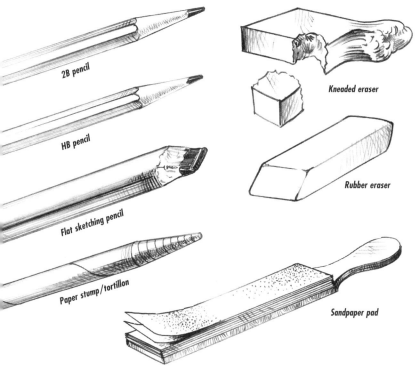

2B pencil

Kneaded eraser

HB pencil

Rubber eraser

Flat sketching pencil

Paper stump/tortillon

Sandpaper pad

PENCILS

Pencils come in varying degrees of lead, from very soft to hard (6B, 4B, 2B, and HB, respectively). Harder leads create lighter lines and are used to make preliminary sketches. Softer leads are usually used for shading. Flat sketching pencils are very helpful; they can create wide or thin lines, and even dots. Find one with a B lead—the degree of softness between HB and 2B. Although pencil is the primary tool used for drawing, don't limit yourself. Try using charcoal, Conté crayons, brush and ink, or pastels—they can add color and dimension to your work.

ERASERS

Erasers are not only useful for correcting mistakes, but they also are fine drawing tools. Choose from several types: kneaded, vinyl, gum, or rubber, depending on how you want to use the eraser. For example, you can mold a kneaded eraser into a point or break off smaller pieces to lift out highlights or create texture. A gum or rubber eraser works well for erasing larger areas.

PAPER

Paper varies according to color, thickness, and surface quality (smooth or rough). Use a sketch pad for practice. For finer renderings, try illustration or Bristol board. As you become more comfortable with drawing techniques, experiment with better quality paper to see how it affects your work.

OTHER HELPFUL MATERIALS

You should have a paper blending stump (also known as a "tortillon") for creating textures and blends in your drawing. It enhances certain effects and, once covered with lead, can be used to draw smeared lines. In order to conserve your lead, have some sandpaper on hand so you can sharpen the lead without wearing down the pencil. You also may want to buy a metal ruler for drawing straight lines. Finally, a sturdy drawing board provides a stable surface for your drawing.

FINAL PREPARATIONS

Before you begin drawing, set up a spacious work area that has plenty of natural light. Make sure all your tools and materials are easily accessible from where you're sitting. Because you might be sitting for hours at a time, find a comfortable chair. If you wish, tape the paper at the corners to your drawing board or surface to prevent it from moving while you work. You also can use a ruler to make a light border around the edge of the paper; this will help you use the space on your paper wisely, especially if you want to frame or mat the finished product.

This is an oval shape.

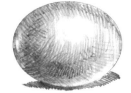

This has a three-dimensional, ball-like form.

As you read through this book, carefully note how the words "shape" and "form" are used. "Shape" refers to the actual outline of an object, whereas "form" refers to the object's three-dimensional appearance.

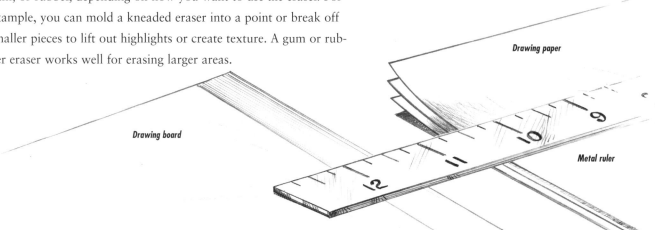

Drawing paper

Drawing board

Metal ruler

Shading Techniques

The drawing tools described on the previous page will allow you to shade skillfully and effectively, giving your subject form and texture. Shading creates the illusion of depth and form of an object through the use of variations in *values*—the relative lightness or darkness of a color or of black.

You also can create different textures by varying the kind of strokes, tools, drawing surfaces, and techniques you use. A pencil sharpened to a chiseled point will create thick strokes, and one with a sharp point will produce narrower strokes. The side of the lead can be used for large, broad shading, and the point for fine details. Choose a softer lead and add more pressure for the dark areas, and leave lighter areas for contrast.

The watercolor brush makes bold, solid lines, whereas the paper stump creates smooth, blended areas.

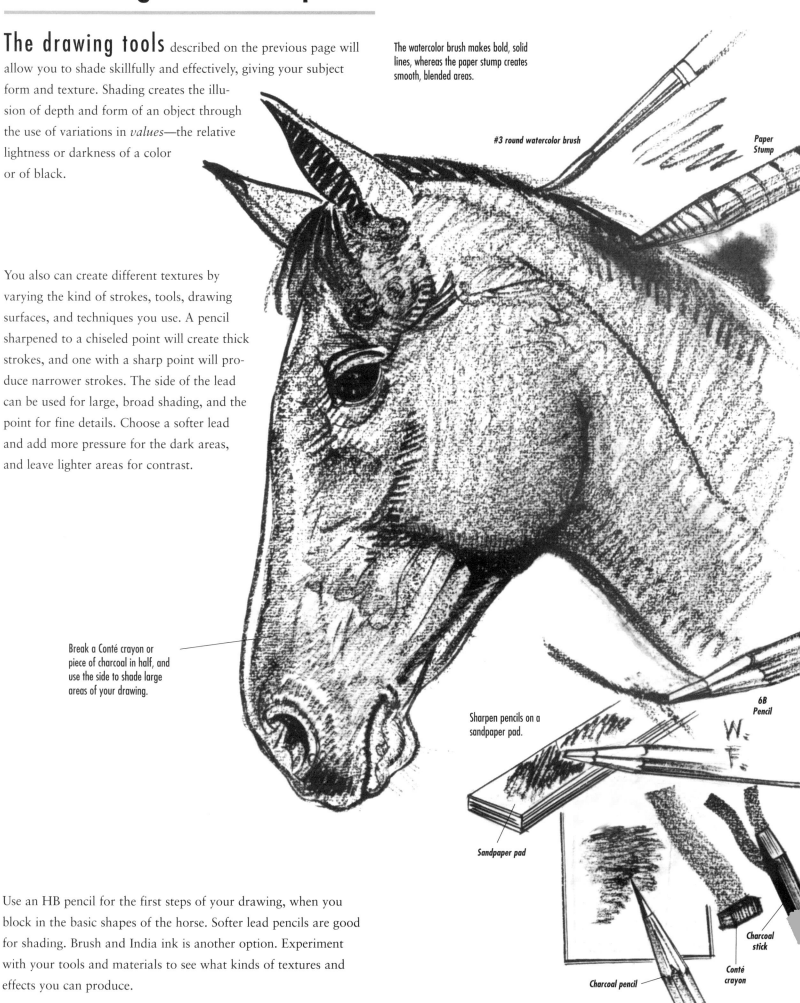

#3 round watercolor brush

Paper Stump

Break a Conté crayon or piece of charcoal in half, and use the side to shade large areas of your drawing.

Sharpen pencils on a sandpaper pad.

6B Pencil

Sandpaper pad

Charcoal stick

Conté crayon

Charcoal pencil

Use an HB pencil for the first steps of your drawing, when you block in the basic shapes of the horse. Softer lead pencils are good for shading. Brush and India ink is another option. Experiment with your tools and materials to see what kinds of textures and effects you can produce.

Anatomy & Proportion

Some knowledge of the horse's anatomy

and proportion is important for correctly blocking in the basic shapes of the subject at the beginning of each drawing.

Proportion refers to the proper relation of one part to another or to the whole, particularly in terms of size or shape. Proportion is a key factor in achieving a likeness of a subject. For drawing animals and people, artists often use head size as a measuring unit for determining the length of other body parts. For example, the body of the horse is about four times the length of its head. Utilizing this kind of approximation will help you draw the horse in correct proportion.

To make realistic drawings, keep in mind that the horse's structure is determined by its skeleton. You don't need to learn the names of all the parts of the horse's anatomy, or even how to draw them; just keep the basic sizes and shapes in mind as you draw. For example, note the triangular shape of the skull, the depth of the rib cage, and the joints in the legs. The vertebrae are slightly higher in the area over the rib cage, forming the base of the horse's withers.

Skeleton

Spine **Vertebrae**

The horse's large eye is set high on its elongated head. Notice the width of the skull from the forehead to the lower jaw and the long, tapered nose.

Hoof

The hoof is a hard, protective covering for the single toe of each foot.

Scapula

Skull

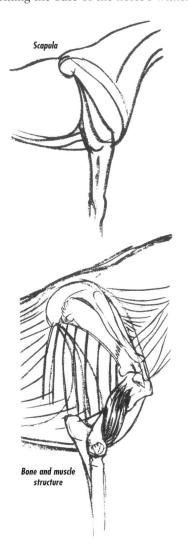

Bone and muscle structure

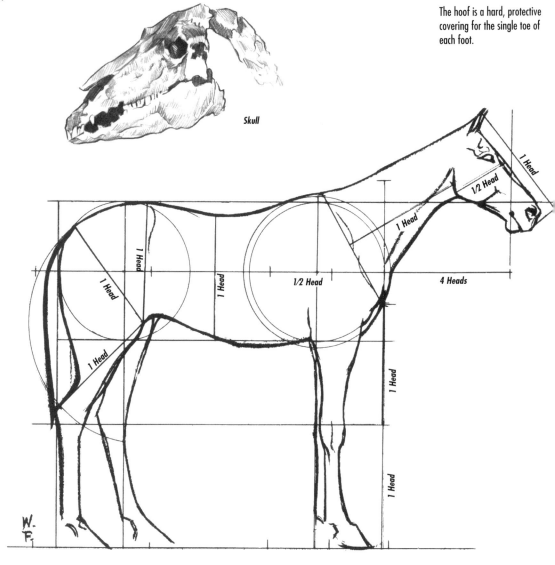

1 Head · 1 Head · 1/2 Head · 4 Heads

1 Head · 1 Head · 1/2 Head · 1 Head · 1 Head · 1 Head · 1 Head

W. F.

Familiarity with the horse's anatomy and musculature will help you make your drawings look realistic. Generally, areas with large, smooth muscles will be shaded lightly, whereas the areas of smaller over-lapping muscles will require more complex shading. Study the illustrations to see how the muscles and tendons wrap around the horse's skeletal structure.

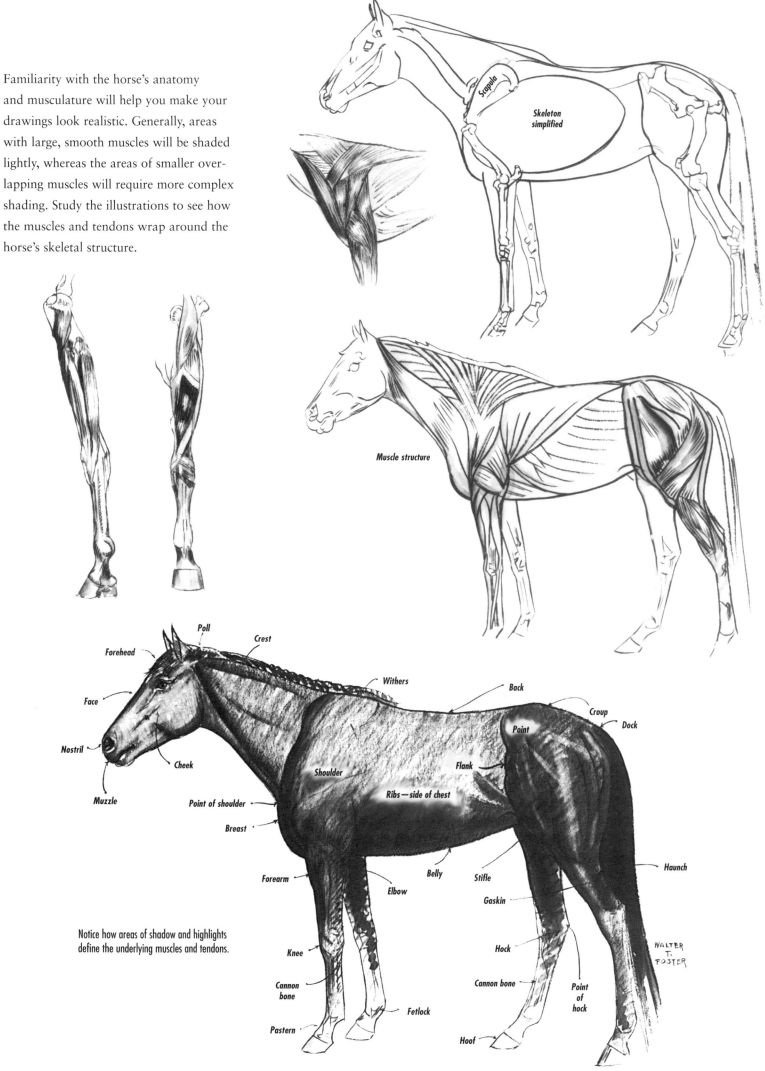

Scapula

Skeleton simplified

Muscle structure

Notice how areas of shadow and highlights define the underlying muscles and tendons.

Poll

Forehead

Crest

Withers

Back

Croup

Dock

Face

Point

Nostril

Cheek

Shoulder

Flank

Muzzle

Ribs — side of chest

Point of shoulder

Haunch

Breast

Belly

Stifle

Forearm

Gaskin

Elbow

Knee

Hock

Cannon bone

Cannon bone

Point of hock

WALTER T. FOSTER

Fetlock

Pastern

Hoof

5

Eyes & Muzzles

Facial features, such as eyes and muzzles, are a good place to start learning to draw horses. If you are a beginner, you might want to practice drawing the parts separately before attempting a complete rendering. Study the drawings on this page, and look at the way the shapes and forms change as the viewing angle changes.

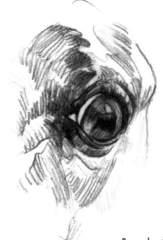

Practice by making many sketches of these features from several different angles. Copy the examples here, or use your own models. Often, details (such as the expression in the eye or the shading around the nostril) are what separate an average drawing from a remarkable one. Start by sketching the general shape with an HB pencil, and then refine the lines until you are satisfied.

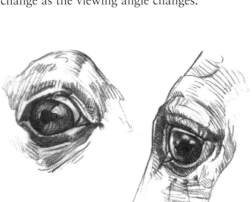

Remember that the eyeball is a sphere, so the eyelid covering it will also be spherical in shape.

As is true for all mammals, horses' eyes reveal their emotions and personality.

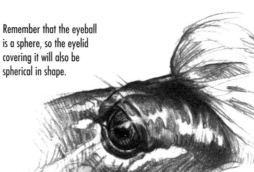

When drawing horses—or any subject— it is best to work from live models or photographs. Trying to draw from memory or imagination is much more difficult. Collect photographs of horses and foals from catalogs, magazines, and books, and keep them in a file for reference. Such a file is commonly called an "artist's morgue."

Horse's faces are not very fleshy, so the planes of the face are quite distinct and reveal the underlying structure of the skull.

The forms of the muscles, veins, and tendons also are easily discernible under the surface of the horse's skin and sleek coat.

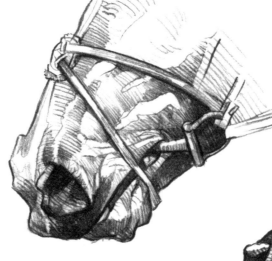

Changes in values and in stroke direction help make your drawings look three-dimensional.

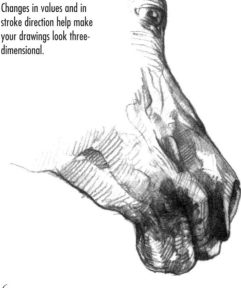

Horses have a few large teeth in the front of their mouth, with a gap on either side between the front incisors and the rear molars.

Ears & Hooves

The position of the horse's ears reveals its
mood. For example, ears pricked forward usually indicate alert interest, whereas ears laid back are a sign of anger, discomfort, or fear. As you practice drawing the ears in different positions, note how shading is used to define the form.

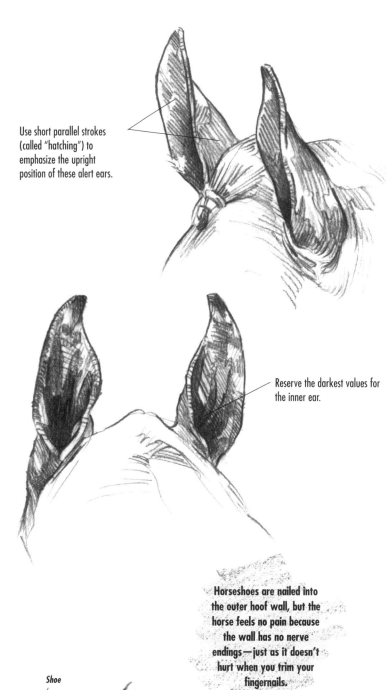

Use short parallel strokes (called "hatching") to emphasize the upright position of these alert ears.

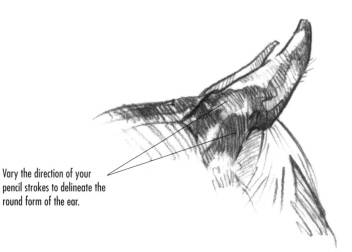

Vary the direction of your pencil strokes to delineate the round form of the ear.

Reserve the darkest values for the inner ear.

The hoof is a hard covering that encloses the underlying toe bone. The frog is the softer, more tender area in the bottom of the hoof. Notice that the hoof is longer in front and shorter in back; make sure your drawings reflect the proper angle of the hoof.

Horseshoes are nailed into the outer hoof wall, but the horse feels no pain because the wall has no nerve endings—just as it doesn't hurt when you trim your fingernails.

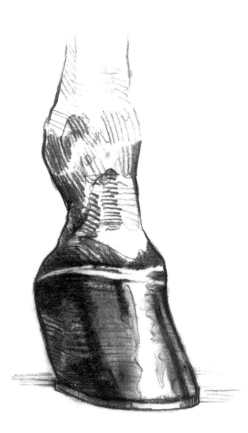

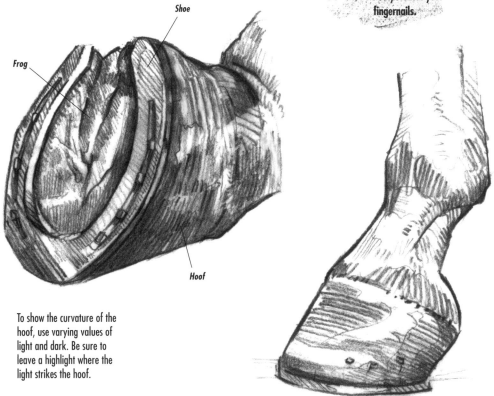

Shoe

Frog

Hoof

To show the curvature of the hoof, use varying values of light and dark. Be sure to leave a highlight where the light strikes the hoof.

7

Basic Heads

The proportions

of this young foal are slightly different from those of the adult horse on the opposite page. It is also shown at a slight three-quarter angle.

In steps A and B, start with the three basic guideline strokes to establish the size and shape of the head. The strokes are numbered to enable you to see the first stroke while you make the second, to ensure that your proportions are accurate. Follow the right- or left-handed approach as needed.

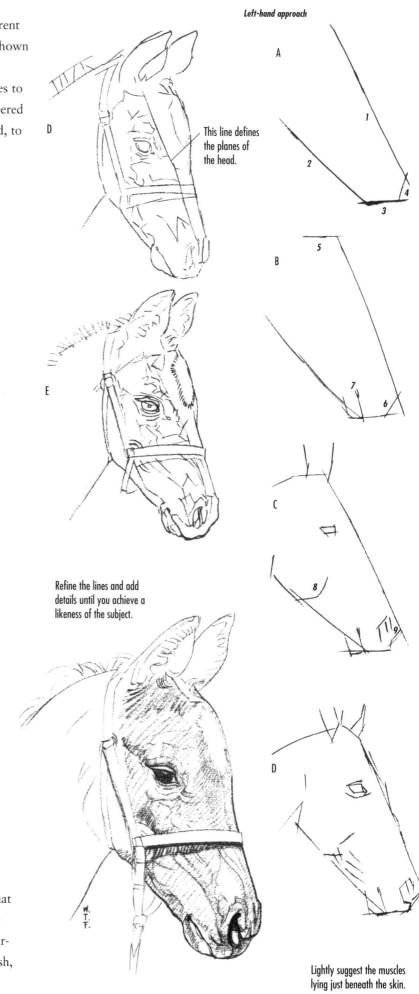

Left-hand approach

This line defines the planes of the head.

Refine the lines and add details until you achieve a likeness of the subject.

Lightly suggest the muscles lying just beneath the skin.

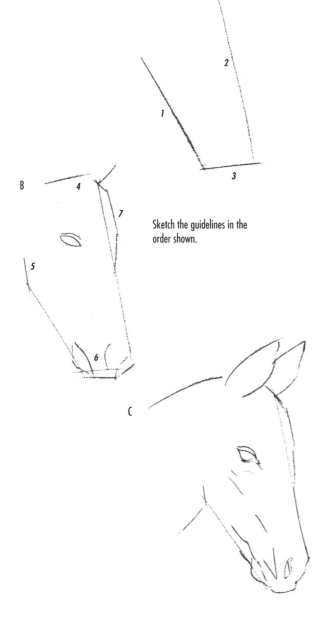

Right-hand approach

Sketch the guidelines in the order shown.

Once you've established the placement of the features, begin refining the lines as shown in steps C and D. Notice the line that extends along the face in step D; this line defines the top plane from the side plane, giving the head a three-dimensional appearance. Continue adding details until you are satisfied. If you wish, add some shading to enhance the form.

Although horses' heads all have a similar basic shape, there are variations among breeds and between individual horses. The drawings here are of a classic thoroughbred profile, with a straight nose and slightly tapered muzzle. Practice drawing many different profiles, and see if you can bring out the unique characteristics in each one.

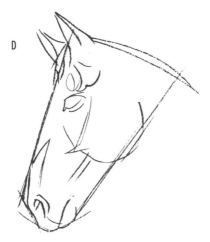

D

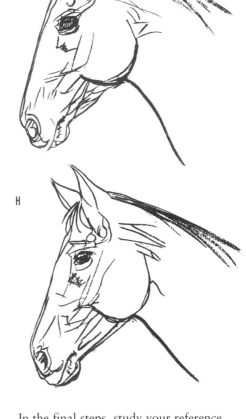

G

A

In steps A and B, use an HB pencil to block in a few basic guidelines to establish the placement and general proportions of the head. Then sketch in the outline of the ears and cheek, and block in the position of the eye, nostril, and mouth, as shown in step C. When you're comfortable with the outline, round out the muzzle, define the features, and suggest the underlying muscles, as shown in steps D and E.

H

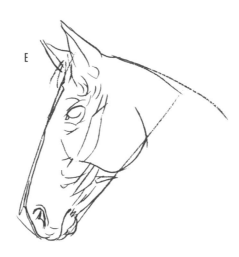

B

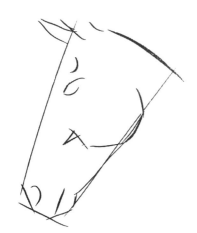

E

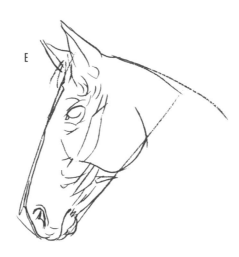

In the final steps, study your reference before further refining the shapes and adding the details. Make note of the length and position of the ears, the angle of the neck, and the curve of the nose and lower lip. Look for the point where the lines of the neck and lower jaw meet the cheek. As your observation skills improve, so will your drawings!

While working out proportions and improving your observation skills, keep the drawing loose and sketchy. You can focus on shading techniques later.

C

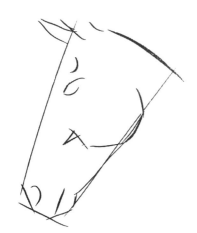

F

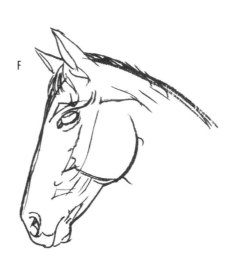

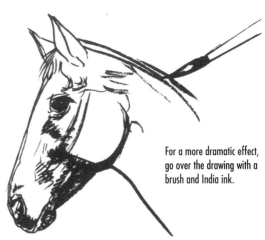

For a more dramatic effect, go over the drawing with a brush and India ink.

Advanced Heads

This profile has been developed a little further than the previous examples were. You will follow the same steps as before, but be more careful and deliberate with your lines and shading strokes. Remember to observe your subject closely, so you can render a good likeness.

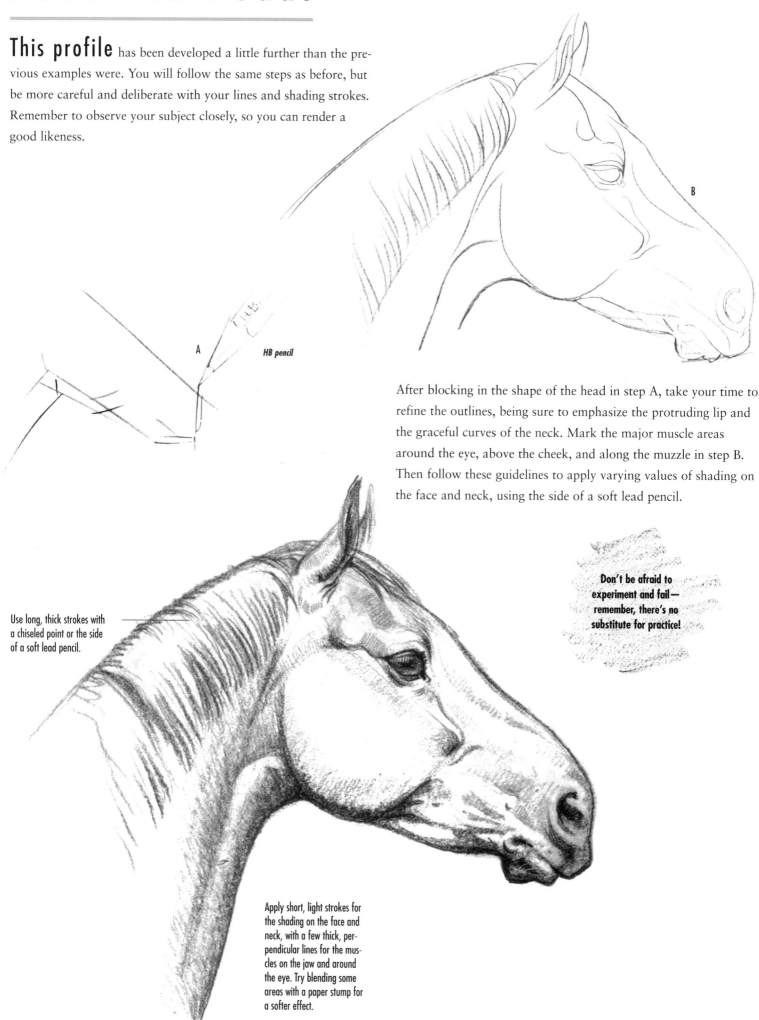

After blocking in the shape of the head in step A, take your time to refine the outlines, being sure to emphasize the protruding lip and the graceful curves of the neck. Mark the major muscle areas around the eye, above the cheek, and along the muzzle in step B. Then follow these guidelines to apply varying values of shading on the face and neck, using the side of a soft lead pencil.

HB pencil

Don't be afraid to experiment and fail—remember, there's no substitute for practice!

Use long, thick strokes with a chiseled point or the side of a soft lead pencil.

Apply short, light strokes for the shading on the face and neck, with a few thick, perpendicular lines for the muscles on the jaw and around the eye. Try blending some areas with a paper stump for a softer effect.

Here are some slightly more complex examples to help you practice shading techniques. Notice the differences in the viewing angles, mane treatments, and tack (the bridles and halters). As always, start with a few block-in lines, refine your outlines, and then add the shading.

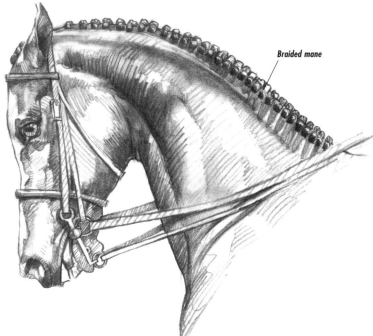

Braided mane

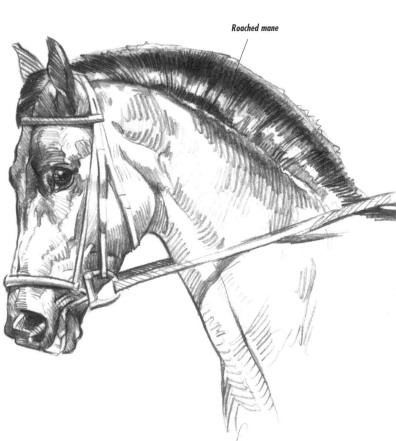

Roached mane

Show horses often have braided manes. Roached manes have been shaved to a few inches in length so they stand straight up. These two mane styles show off the horses' necks and give you the opportunity to practice shading the muscles in the head and neck. Because there are so many differences among breeds, your observation skills will be well tested when drawing horses!

Use short horizontal strokes for the front of the neck, and vary the angle of the strokes on the side to follow the curve of the neck.

As you shade these heads, look carefully at the way the contrast between light and dark values gives form to the horses. Dark and middle values add depth, and the highlights make those areas "pop out." Vary the kinds of strokes you use to emphasize the different textures in the sleek coats, the coarser manes, and the smooth leather of the horses' tack.

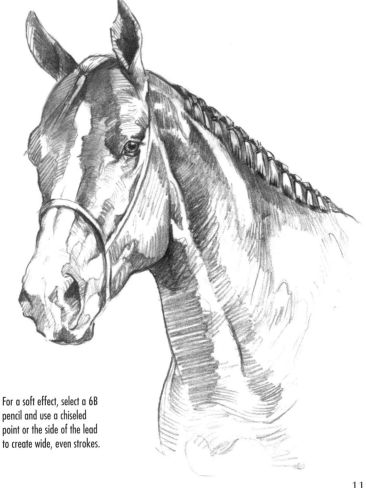

For a soft effect, select a 6B pencil and use a chiseled point or the side of the lead to create wide, even strokes.

Foal's Body

Foals have a great zest

for living and a fine sense of fun. They love to run and kick, and they are as fond of showing off as children are. Try to capture this playfulness in your drawings.

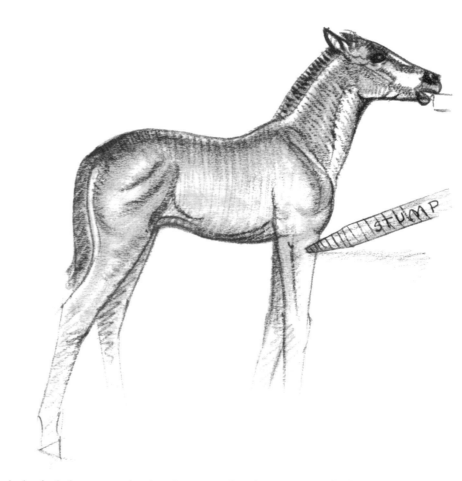

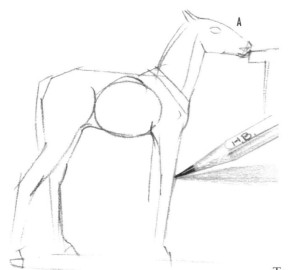

To sketch the foal above, start by drawing an oval with an HB pencil. Block in the body parts around this shape, making sure all the elements are drawn in correct proportion. Notice how long the foal's legs are in relation to its body. Then use a 6B pencil to shade the foal, blending some areas with a paper stump for a soft, rounded effect.

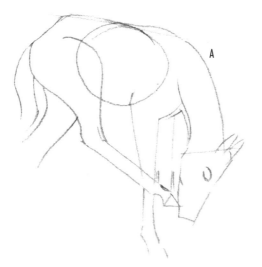

This drawing was made on rough-textured paper and finished using a drybrush technique. After working out the outline of the foal in pencil, apply the light and middle values with washes of India ink or black watercolor paint. Then use a dry brush and undiluted ink to lay in the darkest shadows and details. The *drybrush* technique produces rough, broken lines with feathered edges and is an easy way to create texture.

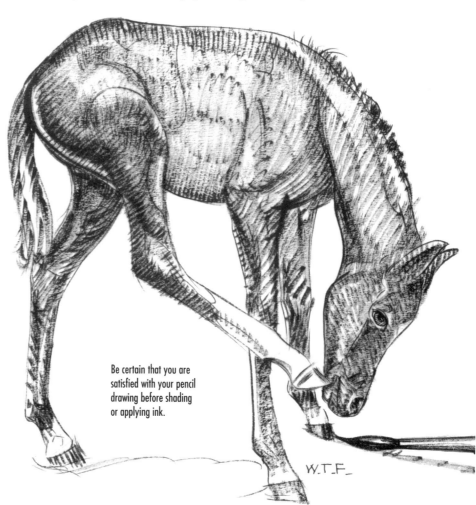

Be certain that you are satisfied with your pencil drawing before shading or applying ink.

Here again, layers of ink washes are used to achieve a more solid rendering. After blocking in the basic shape of the body with an HB pencil, refine the lines until you are satisfied with the proportions and outline. Then use a clean brush to apply clean water over the foal's body, being careful to stay within the outlines. Next load the brush with diluted ink, and wash it over the body in smooth, even layers. This technique is called "wet on wet," and it produces soft, loose blends. Note, however, that the washes are more difficult to control with this method than when painting wet on dry or with the drybrush technique. Experiment with either painting wet on wet or allowing the paper to dry between washes. As you apply your washes, leave some areas lighter for highlights, and brush on extra layers of ink for the dark areas on the neck and belly. Use the tip of a dry brush to draw the fine outlines and details.

A

H.B.

In a trot, this frisky foal's diagonal legs work in unison at a brisk, two-beat gait.

Apply multiple layers of diluted ink for the darkest areas.

Add water to the ink for the gray areas.

Leave some areas white for contrast.

#3 round watercolor brush

W.T.F.

13

Adult Horse's Body

Gaited horses, such as the Hackney, have an extremely high action, or leg carriage. Study your subject carefully to make sure that you draw the leg positions correctly. As you block in this high-stepping horse, begin with an oval for the midsection, and add circular forms for the rump and chest. Then rough in the head, legs, and tail, and start suggesting the major muscle areas, as shown in step A.

Start to indicate the darkest areas with hatching strokes.

Use the side of the lead or a paper stump to shade the darkest areas.

Leave white areas for highlights and contrast.

Vary the direction of the hatching to suggest changes in the form of the horse.

In steps B and C, shade the darkest areas of the horse with thick hatching, following the direction of the different planes and muscles of the horse's face and body. Then use a paper stump to blend some of the middle and dark values. Finally, use the sharp point of a 2B pencil to redefine the outline and some of the hatching.

It's important to get the pose right when you draw a horse rearing up on its hind legs. Remember that the horse's center of gravity is over its shoulders. If you draw the horse leaning too far forward or too far back, the horse will look unsteady.

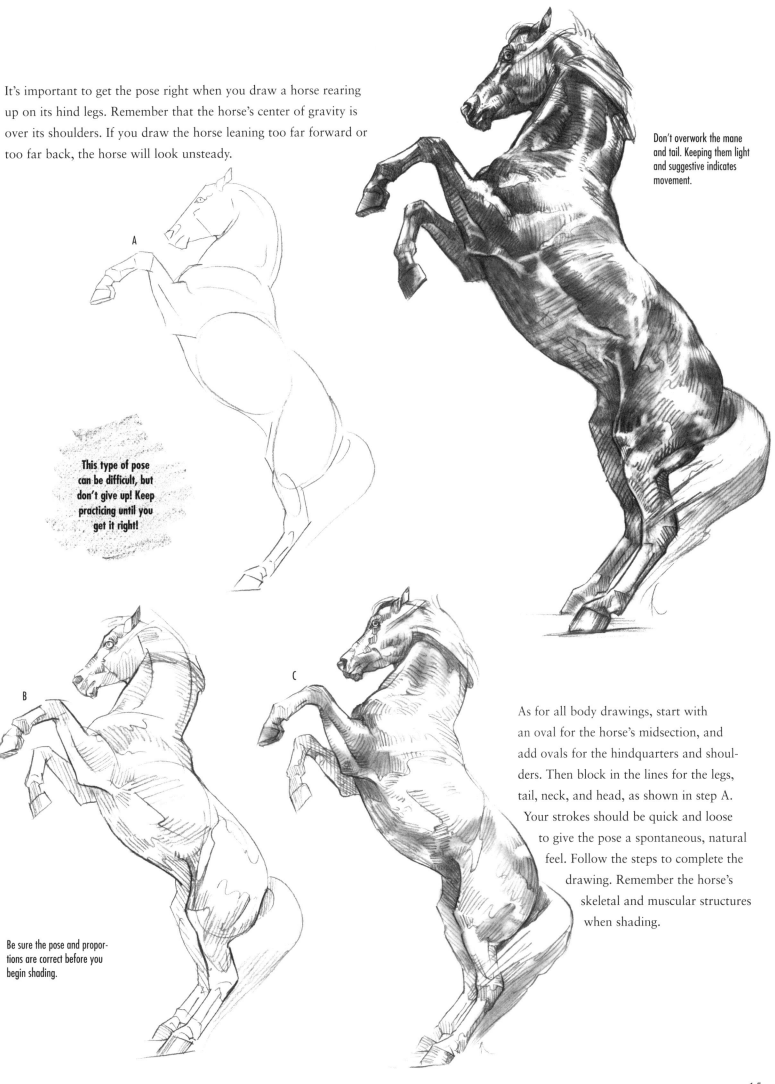

Don't overwork the mane and tail. Keeping them light and suggestive indicates movement.

A

This type of pose can be difficult, but don't give up! Keep practicing until you get it right!

B

Be sure the pose and proportions are correct before you begin shading.

C

As for all body drawings, start with an oval for the horse's midsection, and add ovals for the hindquarters and shoulders. Then block in the lines for the legs, tail, neck, and head, as shown in step A. Your strokes should be quick and loose to give the pose a spontaneous, natural feel. Follow the steps to complete the drawing. Remember the horse's skeletal and muscular structures when shading.

Quarter Horse

The quarter horse is a powerful, muscular breed known for its agility and superior cattle-cutting abilities. The name "quarter horse" is derived from the breed's capacity to run at high speed for distances up to a quarter of a mile. Emphasize the strong hindquarters and muscular neck when you draw this horse.

This pose represents another challenge. Here the horse is viewed from the rear and at an angle, so you will need to use foreshortening techniques in your drawing. *Foreshortening* means to reduce or distort parts of a drawing in order to convey the illusion of depth as perceived by the human eye. In this case, the horse's side is shortened to show that the front of the horse is farthest from the viewer. As a consequence, the rump and hindquarters appear larger in relation to the horse's front end, because that area is closest to the viewer.

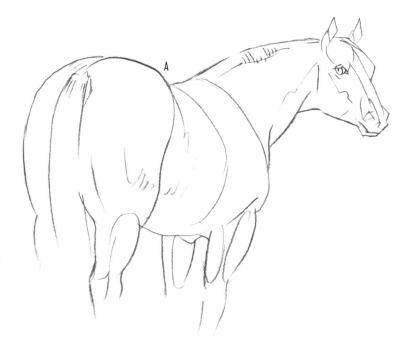

For this complex pose, you'll need to take your time and block it in carefully. Look closely at the distances between the parts of the horse and their sizes in relation to one another. Also pay attention to the form of the legs; this is a new viewpoint that allows you to define the back of the pasterns, knees, and hooves. Check your proportions carefully, and then begin suggesting the shadows and muscle areas in step B.

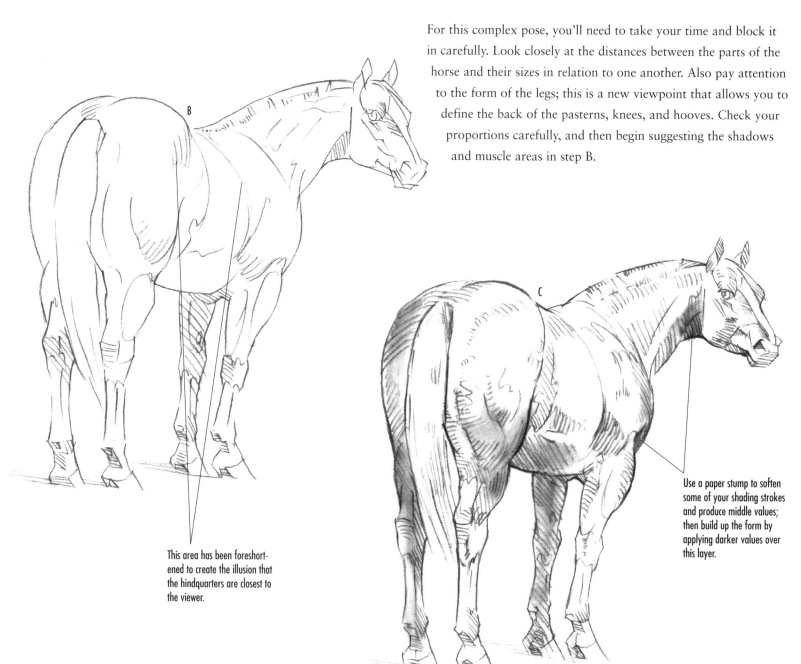

This area has been foreshortened to create the illusion that the hindquarters are closest to the viewer.

Use a paper stump to soften some of your shading strokes and produce middle values; then build up the form by applying darker values over this layer.

As you lay in the dark and middle values in step C, vary the angle of the hatching to follow the planes of the muscles, face, and leg joints. For your final shading, use a soft 2B pencil and a paper stump to smooth out the strokes, leaving strong highlights to bring out the sheen of the horse's coat. Take care not to overwork the legs in your final shading; the light areas show the horse's white "socks."

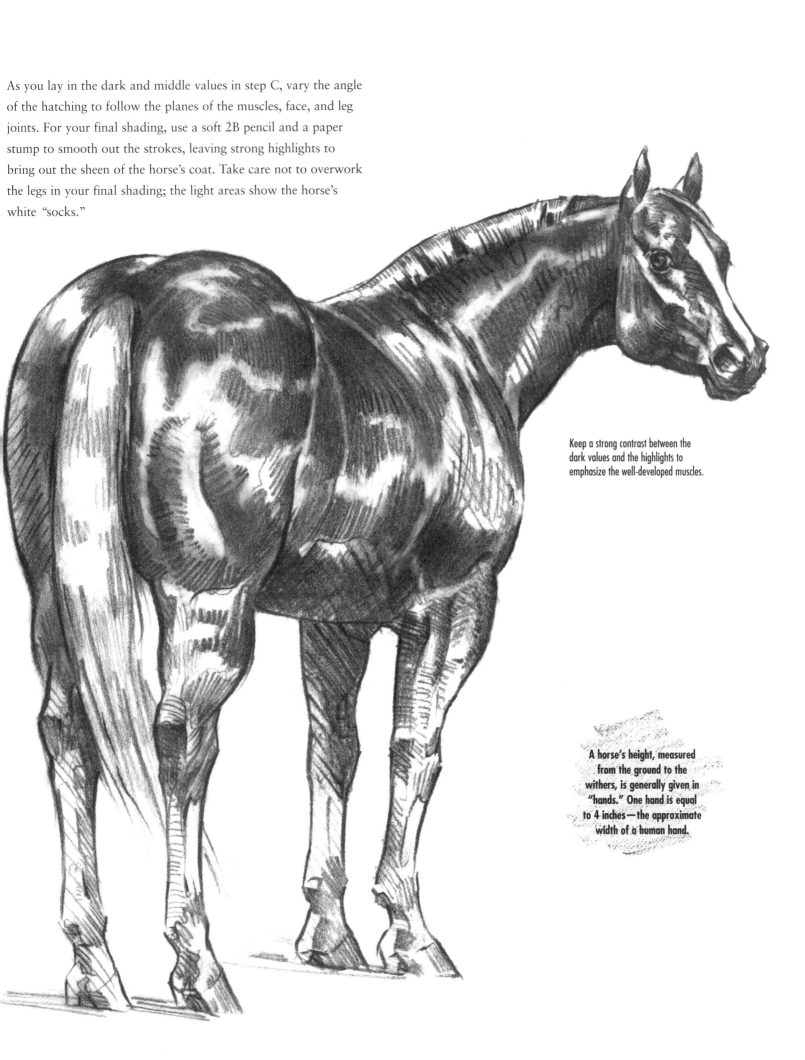

Keep a strong contrast between the dark values and the highlights to emphasize the well-developed muscles.

A horse's height, measured from the ground to the withers, is generally given in "hands." One hand is equal to 4 inches—the approximate width of a human hand.

Clydesdale

The Clydesdale, a large draft horse bred for heavy farm work, is now a popular parade horse easily recognized by its "feathers"—the long hairs around its lower legs. The pose shown here is similar to the pose of the quarter horse, and this draft horse also is a muscular breed. To distinguish the two in your drawings, notice that the larger Clydesdale has a rounder rump, heavier legs, a thicker and more arched neck, and a Roman (arched) nose.

Block in this horse carefully, just as you did for the quarter horse on pages 16 and 17, keeping the principle of foreshortening in mind. Use a soft lead, such as a 2B, to establish the areas of light and dark in step C, and, for contrast, use heavy, straight strokes for the mane and tail.

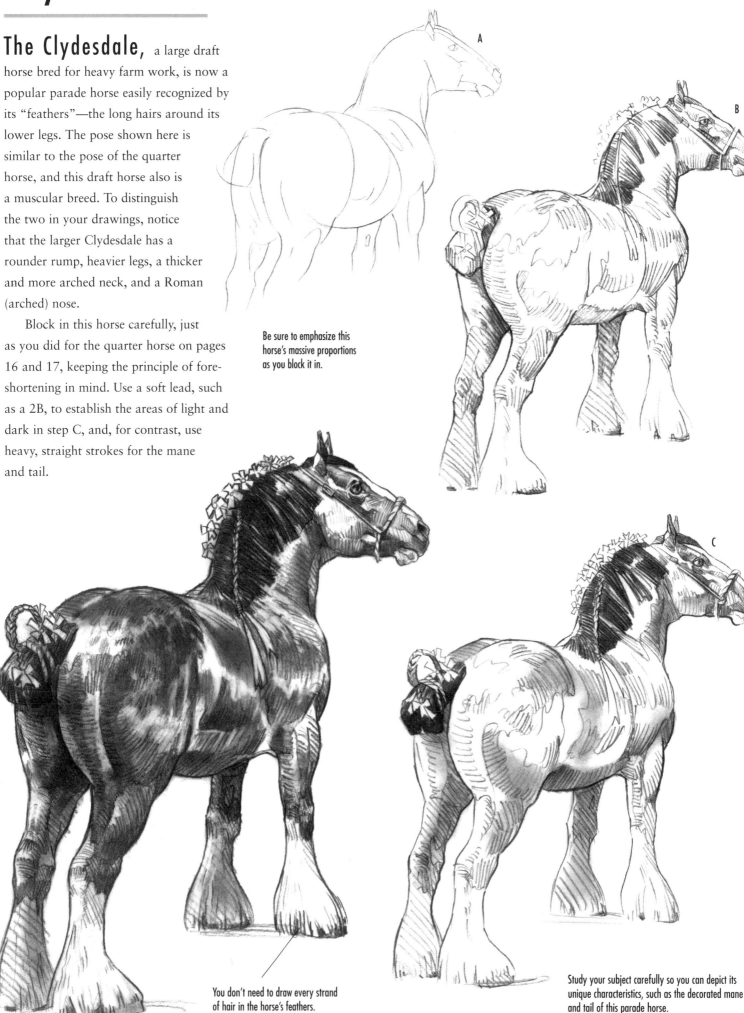

Be sure to emphasize this horse's massive proportions as you block it in.

You don't need to draw every strand of hair in the horse's feathers.

Study your subject carefully so you can depict its unique characteristics, such as the decorated mane and tail of this parade horse.

Circus Horse

Horses used in the circus are large-boned breeds, such as European warmbloods. These breeds have broad backs and strong builds combined with an elegant, graceful carriage. This striking pinto provides good practice for your shading techniques because its coat has both light- and dark-colored areas.

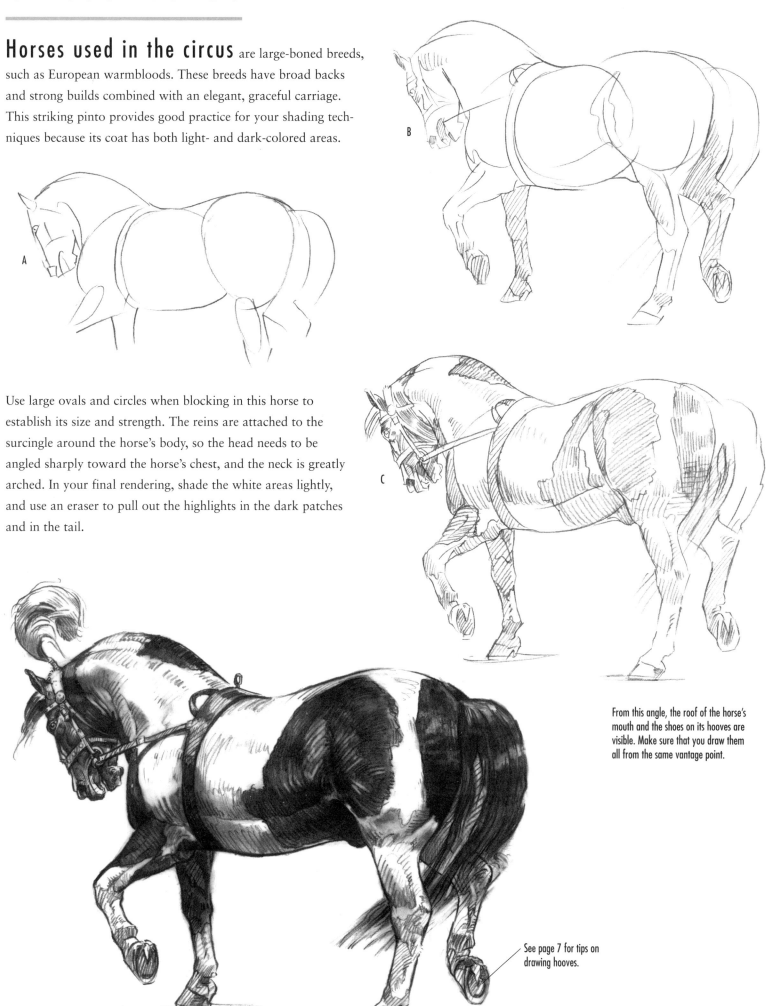

Use large ovals and circles when blocking in this horse to establish its size and strength. The reins are attached to the surcingle around the horse's body, so the head needs to be angled sharply toward the horse's chest, and the neck is greatly arched. In your final rendering, shade the white areas lightly, and use an eraser to pull out the highlights in the dark patches and in the tail.

From this angle, the roof of the horse's mouth and the shoes on its hooves are visible. Make sure that you draw them all from the same vantage point.

See page 7 for tips on drawing hooves.

19

Arabian

The Arabian is a high-spirited horse with a flamboyant tail carriage and distinctive, dished profile. Though relatively small in stature, this breed is known for its stamina, graceful build, intelligence, and energy. Try to capture the Arabian's slender physique and high spirit in your drawing.

Block in the body with an HB pencil, placing the oval for the body at a slight angle to indicate that the body will be foreshortened. Take care when blocking in the head to stress the concave nose, large nostrils, and small muzzle. As you start shading in steps B and C, keep the lines for the tail and mane loose and free, and accent the graceful arch of the neck.

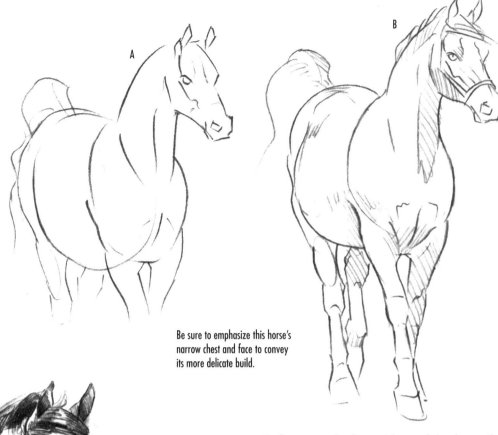

A

B

Be sure to emphasize this horse's narrow chest and face to convey its more delicate build.

From this angle, the line of the spine is visible. Add subtle shading here and along the withers to give your drawing a three-dimensional quality.

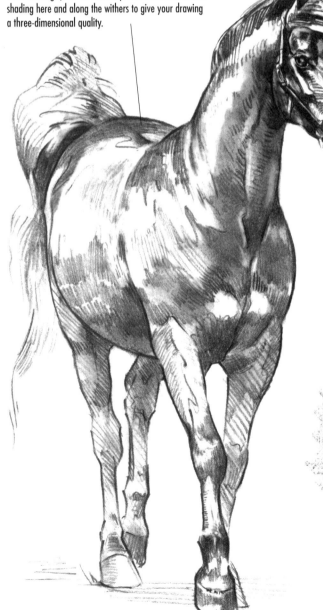

Refine your shading with a soft lead pencil and a paper stump, leaving large areas of white for the highlights. These highlights show the shine on the horse's coat and indicate the direction of the light source.

C

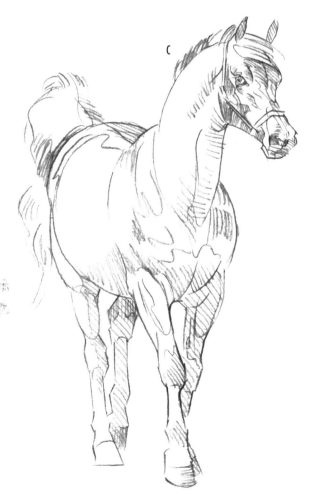

Arabians were highly prized by the desert Bedouins for their stamina and speed.

Shetland Pony

One of the smallest of the pony breeds, the Shetland is a hardy animal originally from the Shetland Islands off of northern Britain. This pony exhibits the characteristic small head, thick neck, and stocky build of the breed.

As you block in the pony's body, carefully observe its proportions—the length of its body is about two-and-a-half times the length of its head. In step A, start with large circles and ovals to capture the pony's solid build. Use hatching strokes to start indicating the middle values as shown in step B, and use a paper stump for the darkest areas in step C.

A

Notice the pony's relatively short, thick neck.

B

C

Use the side of the lead and a paper stump for light, wispy strokes to finish off this light-colored pony.

Horse & Rider in Action

When you depict a horse with a rider, the two should should be drawn as if they are one entity. Develop them both at the same time as you draw. The rider's body, leg, and hand position are important elements that, when drawn correctly, will make your drawings realistic.

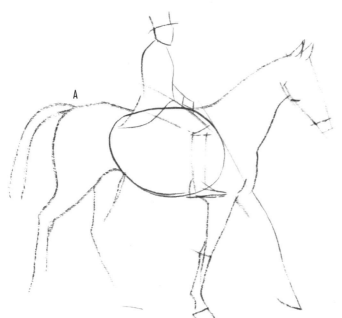

In step A, begin with a horizontal oval shape for the horse's body. Then block in the rider and the horse's head, neck, and legs. Mark the angle of the horse's shoulder line to help you establish the correct angle of the right foreleg. Notice how the horse's hind foot turns backward as it lifts off the ground.

Practice drawing the horse's various gaits, as shown in this series of sketches. Take note of the rider's position. At a walk, the horse's head is upright, and the rider's body is perpendicular to the horse's.

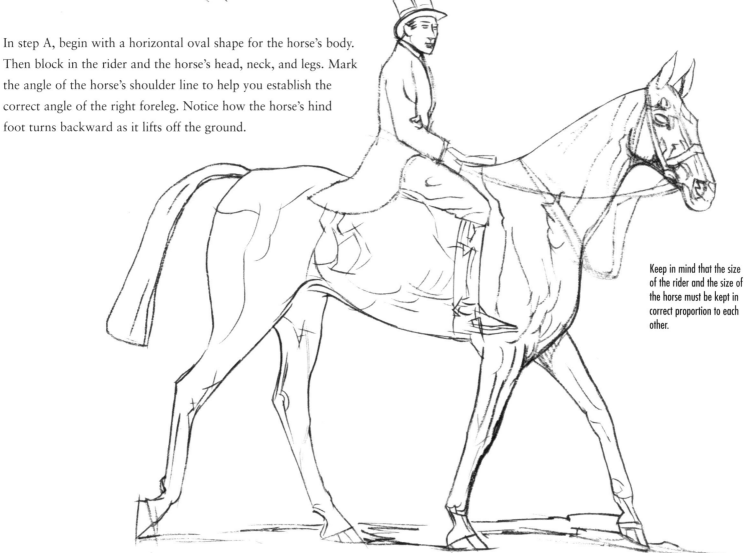

Keep in mind that the size of the rider and the size of the horse must be kept in correct proportion to each other.

The slow, loping gait of a horse is called a "canter." At this moderate pace, the horse's center of gravity is shifted slightly forward, which is evident in the forward thrust of the head and body. Notice that the rider is leaning forward toward the horse's head, following the horse's motion with his own body. Keep your lines fluid and loose to convey the sense of movement.

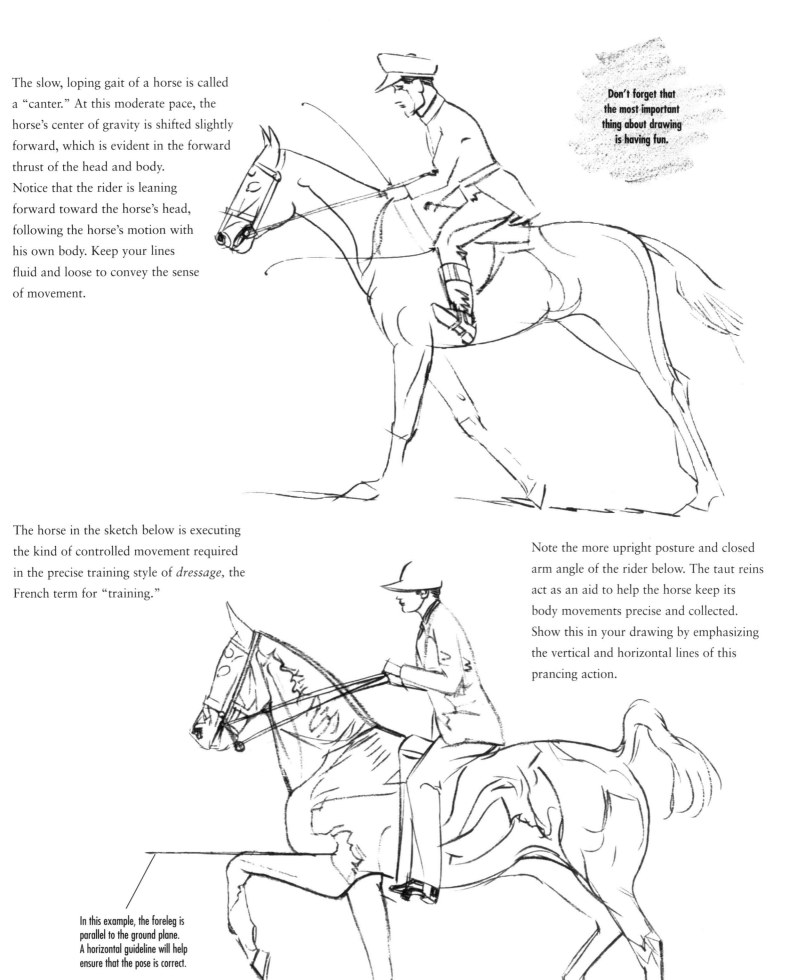

The horse in the sketch below is executing the kind of controlled movement required in the precise training style of *dressage*, the French term for "training."

Note the more upright posture and closed arm angle of the rider below. The taut reins act as an aid to help the horse keep its body movements precise and collected. Show this in your drawing by emphasizing the vertical and horizontal lines of this prancing action.

In this example, the foreleg is parallel to the ground plane. A horizontal guideline will help ensure that the pose is correct.

The Gallop

The gallop is the horse's fastest gait; some horses can reach a speed of 35 miles per hour at a full gallop. At one point in this three-beat gait, all four legs are off the ground at the same time; at another point, all the horse's weight is supported by only one leg, as shown in this pose.

Because this horse is viewed at an angle, the oval for the body must be angled. Block in the chest and hindquarters with circles, and use angular lines for the knees and face, as shown in step A. Keep the tail lines tail free-flowing.

Don't overwork your final shading; use just enough to suggest the form. The large area of white indicates a strong light source but also gives this horse a light, airborne quality.

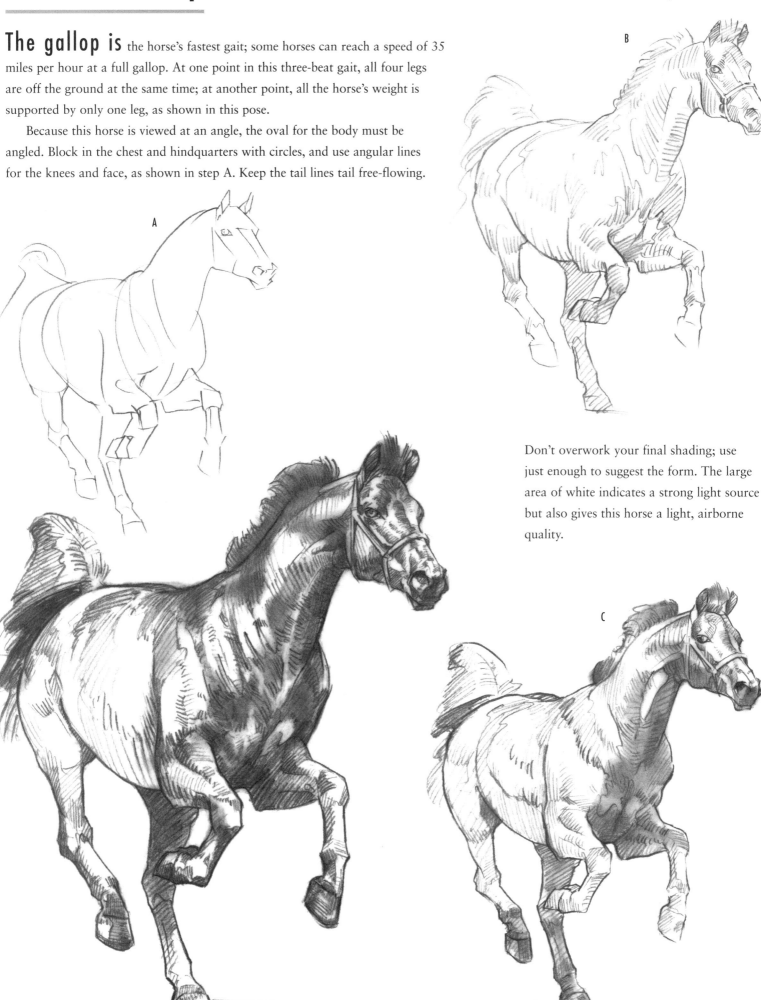

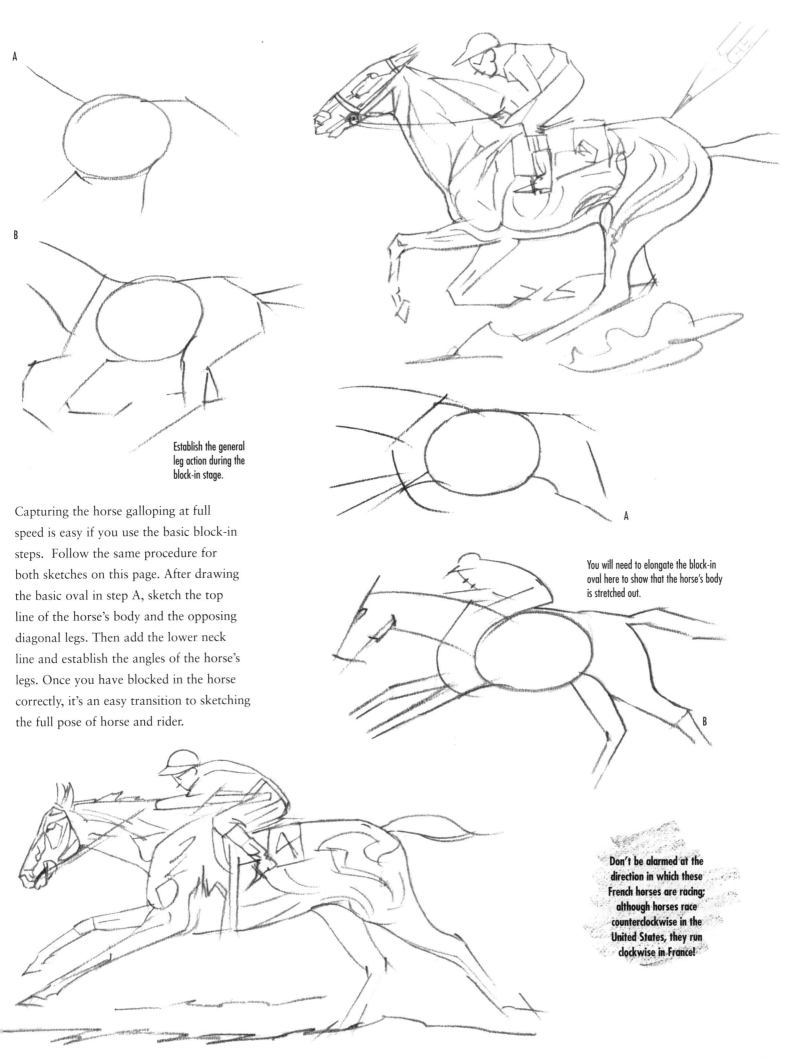

A

B

Establish the general leg action during the block-in stage.

Capturing the horse galloping at full speed is easy if you use the basic block-in steps. Follow the same procedure for both sketches on this page. After drawing the basic oval in step A, sketch the top line of the horse's body and the opposing diagonal legs. Then add the lower neck line and establish the angles of the horse's legs. Once you have blocked in the horse correctly, it's an easy transition to sketching the full pose of horse and rider.

A

You will need to elongate the block-in oval here to show that the horse's body is stretched out.

B

Don't be alarmed at the direction in which these French horses are racing; although horses race counterclockwise in the United States, they run clockwise in France!

The Jump

Jumping is an exciting

horse sport, whether it's stadium show jumping, cross-country racing, or steeple-chasing. Notice how dramatically the rider shifts his body position to follow the horse's movement. The rider must remain over the horse's center of gravity to help the horse maintain its balance and to keep from hindering the horse's effort. Being aware of these details will help keep your drawings accurate.

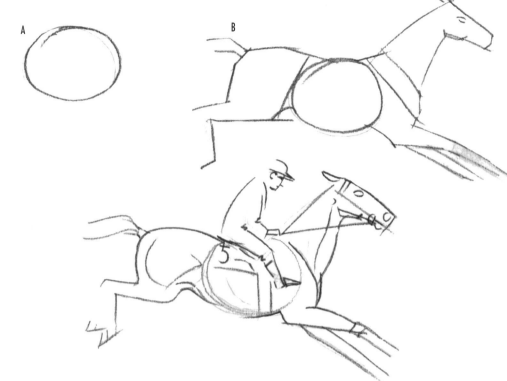

A

A

B

Use either an HB or a 2B pencil for these sketches.

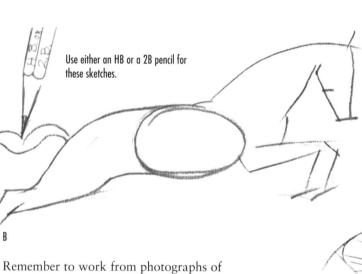

B

When drawing a horse in motion, keep the lines clean and simple. Clean, sweeping lines help convey a sense of the action involved. Make a lot of rough sketches like these to practice capturing the feeling of movement in your drawings.

Remember to work from photographs of horses in various activities. This will help you check the accuracy of the horse's leg movement and the rider's position.

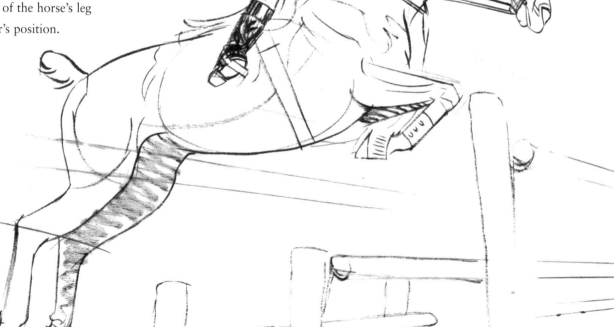

26

Polo Pony & Player

Polo is a fast-paced sport

that requires speed and agility in both horse and rider. The horse's flaring nostrils show the energy the horse expends, and the dramatic angles of the rider's body illustrate the player's range of motion. It's important to capture the action of both the horse and rider before going on to shade the drawing.

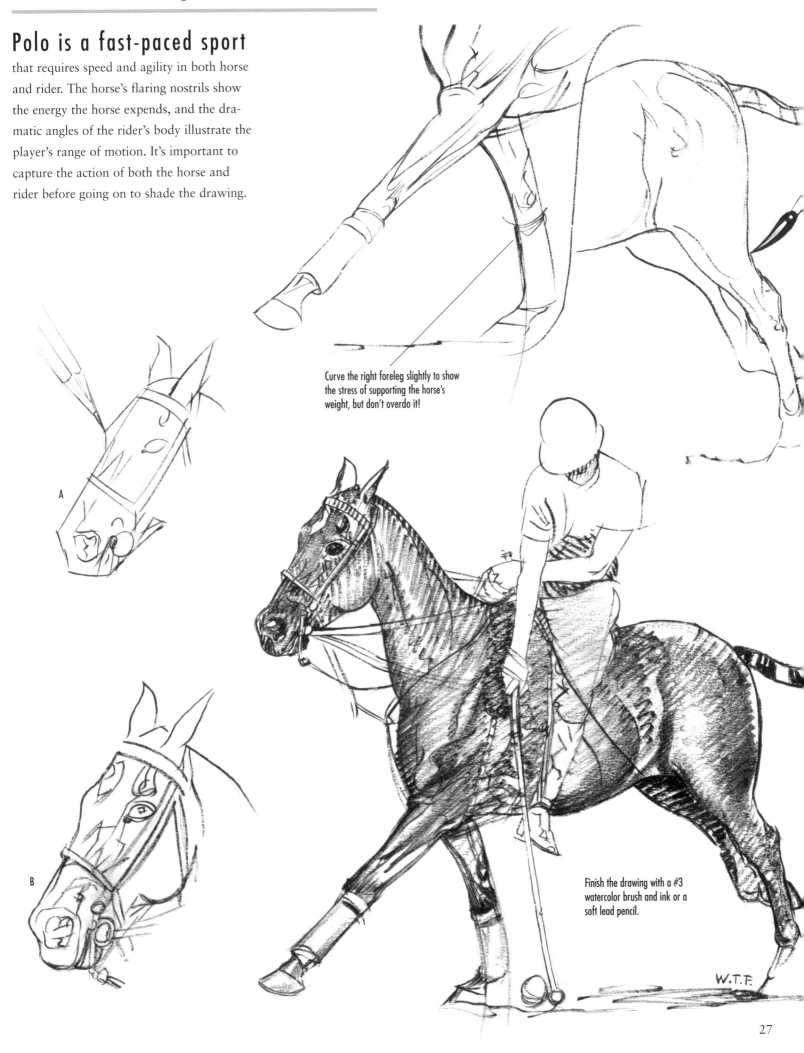

Curve the right foreleg slightly to show the stress of supporting the horse's weight, but don't overdo it!

A

B

Finish the drawing with a #3 watercolor brush and ink or a soft lead pencil.

W.T.F.

Racehorse & Jockey

This closeup drawing of a horse and jockey was completed with brush and ink. First use an HB pencil to block in the horse's head, and then develop the jockey's pose. Be sure to correctly establish the action and rhythm of the horse and rider, as well as the horse's expression, before applying the ink.

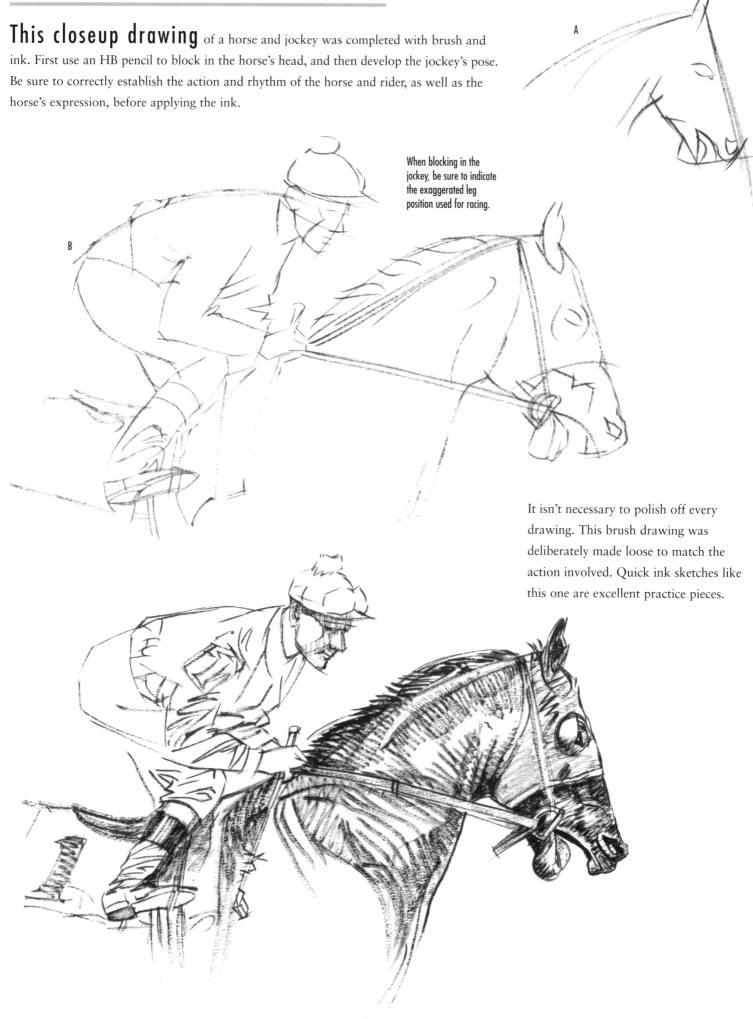

A

When blocking in the jockey, be sure to indicate the exaggerated leg position used for racing.

B

It isn't necessary to polish off every drawing. This brush drawing was deliberately made loose to match the action involved. Quick ink sketches like this one are excellent practice pieces.

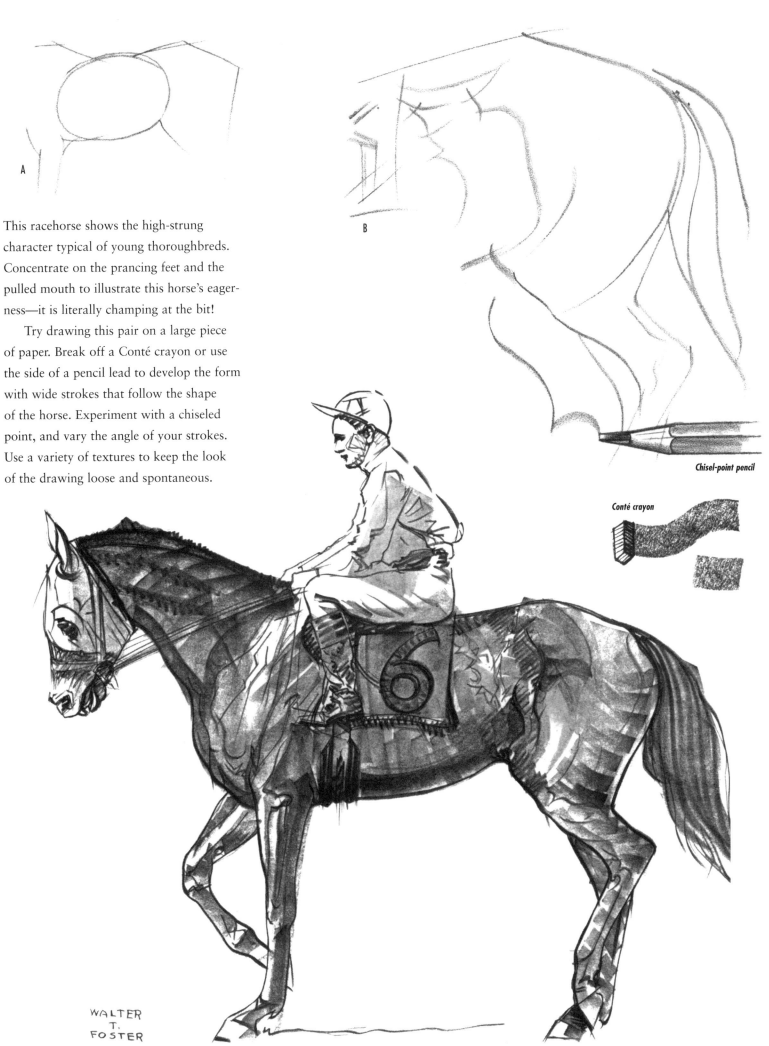

A

B

This racehorse shows the high-strung character typical of young thoroughbreds. Concentrate on the prancing feet and the pulled mouth to illustrate this horse's eagerness—it is literally champing at the bit!

Try drawing this pair on a large piece of paper. Break off a Conté crayon or use the side of a pencil lead to develop the form with wide strokes that follow the shape of the horse. Experiment with a chiseled point, and vary the angle of your strokes. Use a variety of textures to keep the look of the drawing loose and spontaneous.

Chisel-point pencil

Conté crayon

WALTER
T.
FOSTER

Western Horse & Rider

The western rider's attire and horse's tack reflect their cowhand heritage. The western stock saddle is larger and deeper than the flat racing or jumping saddles. Cowhands need to be firmly and comfortably seated while executing the quick maneuvers required for cutting cattle. Also notice that the western stirrup is worn longer, so the rider's leg has a straighter angle than that of English riders.

Take care when you block in the horse's right hind leg, and study the shape of the muscles and joints; this is a bit of a tricky angle.

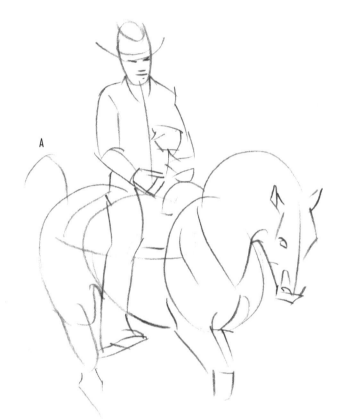

This pair has a lot of detail, so take care when blocking in. Distort the oval for the horse's body to show the viewing angle, and place circles for the horse's shoulders and hindquarters in step A. Don't forget to block in the saddle horn as well. When you sketch in the rider, pay careful attention to his foreshortened arm and the angle of his boot.

Check your proportions carefully as you begin developing your drawing in step B, and note the rider's hand position. Western riders hold both reins in one hand, so one hand is free for other work. Make the horse's neck arched and relaxed, and study the placement of the horse's legs. Then begin laying in the shadows in step C.

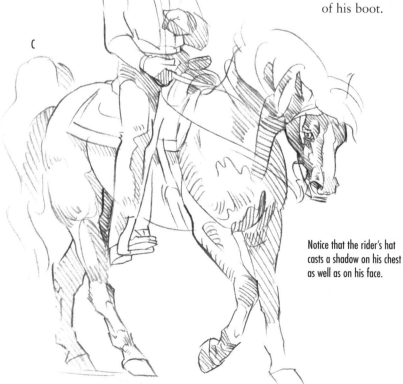

Notice that the rider's hat casts a shadow on his chest as well as on his face.

In your final drawing, apply the shading techniques you've learned so far to make the drawing appear three-dimensional. Now is the time to add the details on the saddle and the rider's clothing. The rider's belt buckle, the tooling on the saddle, and the intricacies on the horse's bridle are important components that make this pair unique. Now all your drawing practice and observation training will really pay off!

The next time you study a horse, think about what makes it special, and try to capture that quality in your drawings. Happy drawing!

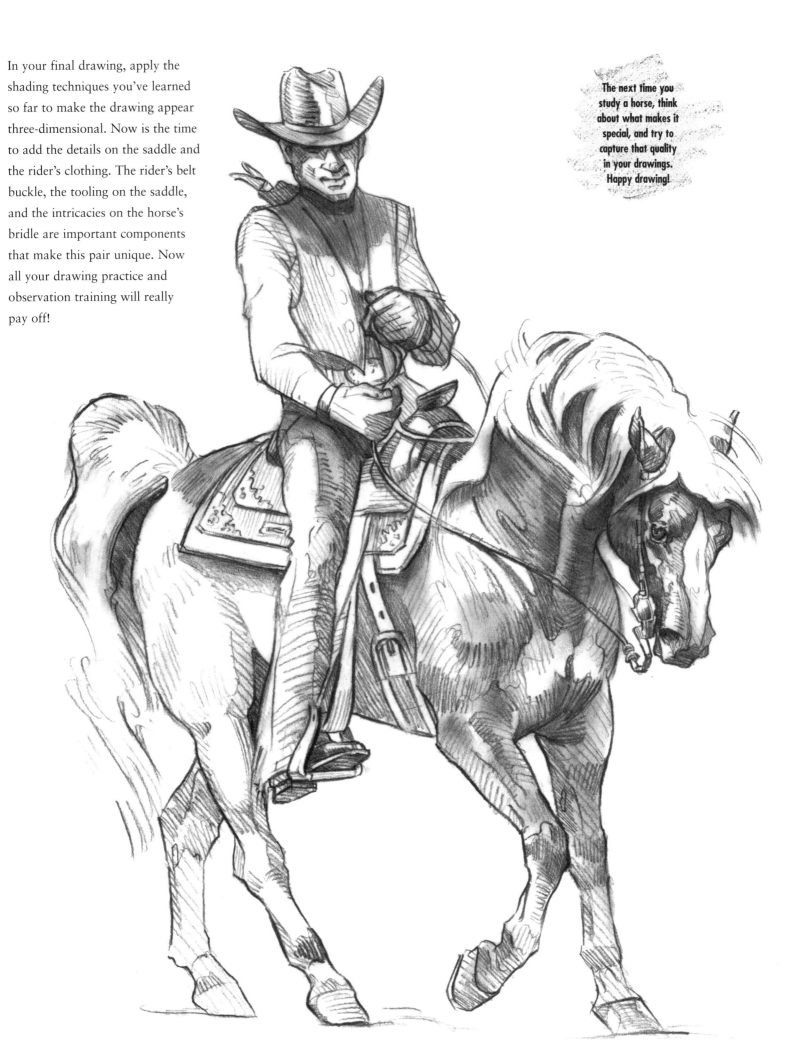

Walter Foster presents a new series

THE ART OF DRAWING

Bringing you quality art instruction in a unique format, the books in this series are designed with the aspiring artist in mind. Based on the best-selling books from Walter Foster's How to Draw and Paint series, these six titles showcase an exciting array of subjects to re-create in pencil—from stunning floral scenes to lifelike portraits. Each book provides a helpful introduction to pencil drawing, complete with information on tools, materials, and basic techniques. These how-to-draw books also feature concealed wire-o binding, so artists can lay them flat while they draw. And each title in this series includes twenty pages of drawing paper bound into the back of the book—perfect for artists on the go!

THT266

THT267

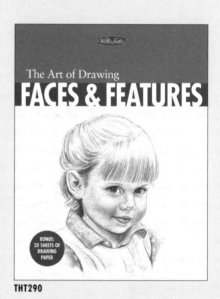

THT290

THT286

THT255

THT11

MORE TITLES COMING SOON!

For more than 80 years, products bearing the Walter Foster name have introduced millions of budding artists to the joys of creative self-expression in painting and drawing. Continuing that tradition of quality and authority, each of Walter Foster's The Art of Drawing books is a 32-page art lesson that will expand your knowledge of different drawing techniques. Ask for these books at your local arts and crafts store, or visit our website at www.walterfoster.com. You'll want to collect them all!